POSTCARD HISTORY SERIES

*Along Iowa's
Historic Highway 20*

Happy travels.
Michael J Hiel

HISTORIC HIGHWAY 20 ACROSS NORTHERN IOWA. Spanning the state from the Mississippi to the Missouri River, historic Highway 20 was northern Iowa's principal artery for both commercial and leisure travel from 1926 until the arrival of the Interstate Highway System. (Author's collection.)

ON THE FRONT COVER: A TYPICAL IOWA MAIN STREET. The original Highway 20 typically went from main street to main street as it passed through cities and towns along its route. Here, the road is heading west through Dyersville on its journey across Iowa. St. Francis Basilica, one of the state's most historic buildings, is in the distance. (Author's collection.)

ON THE BACK COVER: A WELCOMED STOP FOR HIGHWAY 20 TRAVELERS. Travelers along the country's early highways encountered a variety of accommodations ranging from rooms in private homes to small frame cabins, converted farm buildings, and even faux tepees. This small motel utilized Quonset buildings reminiscent of World War II barracks. (Author's collection)

POSTCARD HISTORY SERIES

Along Iowa's Historic Highway 20

Michael J. Till

ARCADIA
PUBLISHING

Copyright © 2014 by Michael J. Till
ISBN 978-1-4671-1290-1

Published by Arcadia Publishing
Charleston, South Carolina

Printed in the United States of America

Library of Congress Control Number: 2014938260

For all general information contact Arcadia Publishing at:
Telephone 843-853-2070
Fax 843-853-0044
E-mail sales@arcadiapublishing.com
For customer service and orders:
Toll-Free 1-888-313-2665

Visit us on the Internet at www.arcadiapublishing.com

To all who remember the crowding and heat in the backseat of the family sedan before the days of air-conditioning, iPods, and smartphones

Contents

Acknowledgments		6
Introduction		7
1.	Across the Mississippi River	9
2.	The Cedar and Iowa River Valleys	43
3.	The Boone, Des Moines, and Raccoon River Valleys	77
4.	Approaching the Missouri River	101

Acknowledgments

Thanks are due to the long-ago civic leaders and business owners who had the foresight to recognize the value of picture postcards in promoting their communities. These visual and historic records provide invaluable insights into "the way it was" in the days when two-lane highways and mom-and-pop tourist courts reigned supreme. Thanks also to the vendors of vintage postcards without whose help this book would have been more difficult if not impossible. Many searched for Highway 20 cards for me, which was greatly appreciated. The same is true for persons responsible for modern web pages describing towns and historic sites on Highway 20. I have borrowed freely from their descriptions and wish to acknowledge their contributions.

Librarians and staffs of county historical societies and museums along Highway 20 were helpful in directing me to interesting information about the road. Many shared personal memories of the postcard sites, and if someone did not know the answer to a question, their telephone call to a longtime resident of the community usually produced the information. Thus, many grandparents, uncles, aunts, and community elders contributed indirectly to this book.

Last but certainly not least, I wish to thank my wife, Christine, for her help. A librarian herself, she knew sources of information and how to access them. She also was an excellent collaborator as we drove historic Highway 20 researching specific sites. Many of her observations have been incorporated into the captions in the book.

All images in this book come from the author's personal collection.

Introduction

Highway 20 across the United States is a result of the Federal Aid Highway Act of 1921. This landmark legislation was enacted to answer the demand for better roads, as motorized travel gained in popularity during the early 20th century. The act provided funding for development and maintenance of seven percent of each state's road system, provided the roads were "interstate in character," meaning that the designated roads in one state must connect with similarly designated roads in the adjacent states. Thus, the original federal highways were not new roads but rather existing roads that when joined together formed a continuous nationwide transportation network. The roads to be included were identified by 1923, and in 1926, the first Interstate Highway System came into existence. The numbering system was adopted, which is still in use today. Major east-west routes were assigned a number ending in "0," and the numbering sequence was from north to south. To avoid the unique number "0," the northernmost road was given the designation "2," and the remaining roads were designated 10, 20, 30, and so on to 90. Highway 2 extended from Maine through New York, but then it was separated by the Great Lakes before beginning its western section from Michigan to the Pacific Ocean. Highway 10 extended only from the Midwest to the West Coast. From 1926 to 1940, Highway 20 extended from Boston to the east entrance of Yellowstone National Park. In 1940, the western section was completed to Newport, Oregon, making Highway 20 the northernmost of the true cross-country highways, and at 3,365 miles, the longest. Although not as famous as its cousins Highway 30 (much of which coincided with the original Lincoln Highway) or Route 66 (which is not cross-country), Highway 20 nonetheless served with equal importance in introducing automobile and truck traffic to America.

The country's original federal highway system owes much to the brilliance of Iowan Thomas McDonald, chief of Iowa's Bureau of Roads. He was far ahead of his time in recognizing the need to organize the roadways of the day into cohesive units. While still a young engineer, McDonald analyzed Iowa's roads to determine which were the most used, which had the most potential for economic benefit, and which types of road surfaces were best for the prevailing conditions. McDonald's talents were quickly recognized, and he was offered the position of Federal Highway director but at a salary less than what he was being paid in Iowa! After some negotiation, he accepted the position, where he became a pivotal figure in furthering the early interstate highways described above.

Thanks to McDonald's expertise, Iowa's highway system was further developed than most other states when Federal Highway Aid became available in 1926. The route from Dubuque to Sioux City was well established, although much of the road surface was still gravel. Citizens

along the route realized the road's importance, and they worked hard to promote it. Named highways were popular at the time, and by 1910, two names had been suggested. The first, River-to-River Highway, emphasized the termini at the Mississippi and Missouri Rivers. Hawkeye Highway proved to be more popular, and that name is still heard occasionally today. The majority of the Hawkeye Highway was selected for inclusion in the first federal highway system, and the designation Highway 20 has served well for almost a century.

The advent of the Interstate Highway System in the 1950s was a boon for motorized travel, but it had a downside. Frequently, the course for the new superhighways was directly over the former local roads. The latter were simply bulldozed away, thus completely obliterating their existence together with the memories they evoked. Fortunately, Highway 20 escaped this fate. The original road has survived almost entirely intact, and to this day, it remains a pristine "country highway," epitomizing the charm and beauty of rural Iowa. Modern Highway 20 and Iowa's Interstate 80 parallel original Highway 20 rather than being superimposed directly on top. Most roads and streets that carried the original Highway 20 still exist. Local numerical or street names have been assigned, but with a bit of effort, one can still follow historic Highway 20 across Iowa much as our ancestors did decades ago.

Highway 20 was the road to follow for both personal and commercial travel across northern Iowa. It connected four of the state's larger cities, Dubuque, Waterloo, Fort Dodge, and Sioux City, and united the smaller communities into a cohesive transportation corridor. Early motorists got a close-up view of the towns and cities along the path of their journey, and they took advantage of the stores, restaurants, service stations, and tourist accommodations. City officials and entrepreneurial merchants quickly recognized the value of advertising their wares to the traveling public. Inexpensive or even free picture postcards were popular vehicles for showing off their cities. Professionally produced picture postcards provided a convenient record of the trip, and typically, they were less expensive and of higher quality than travelers could produce with their own cameras. Many picture postcards found their way into personal scrapbooks. These postcards provide the basis for this book.

Along Iowa's Historic Highway 20 is not a book of roadside curiosities, although the road had its share. Rather, the purpose was to recreate a journey across Iowa as close to its original route as possible, using vintage picture postcards as illustrations. It is intended to give a glimpse of where early travelers might have stopped for gas, to eat, to spend the night, and especially what they would have seen along the way. The route was determined by following road maps and travel guides from the 1920s to the 1940s and extrapolating information to current streets and roads. Whenever possible, local knowledge of the route was included. The postcards show main streets, service stations, diners, tourist homes, cabin courts, and early motels. Notable scenic and historic locations along the route also are included. Many of the scenes were located directly on historic Highway 20 or could be viewed by a person traveling by automobile on the highway. All are from communities through which Highway 20 passed. Many of the sites still exist, although not necessarily serving their original purposes. The overall objective was to provide a guide, as well as a nostalgic record, for anyone wishing to replicate the experience of driving across Iowa on Highway 20 in the pre-interstate era.

One

ACROSS THE MISSISSIPPI RIVER

Dating from the earliest westward migration across the country, the Mississippi River has been the figurative, although not the actual midpoint, on the journey. In reality, on an east-to-west journey, the river lies only slightly more than one-third of the cross-country distance. Nevertheless, travelers arriving at this landmark location felt they were on the homestretch.

Highway 20 enters Iowa at Dubuque, named for Julien Dubuque, a French explorer who was thought to be the first permanent white settler in the territory that was to become Iowa. He was attracted by rumors of lead ore deposits on either side of the river, which proved to be true, and the region grew into a major lead mining center. Julien Dubuque was accepted by the indigenous Mesquakie tribe and is said to have married the chief's daughter Potosa. The lead mines, together with their favorable location on the Mississippi River, enabled Dubuque to grow into one of the foremost industrial, business, and cultural centers in the Midwest, and proximity to thousands of acres of fertile farmland contributed to its success. The city became a major port for shipping agricultural and manufactured goods up and down the river and from there around the world. Dubuque also became a center for higher education and is home to three four-year, degree-granting colleges.

Following historic Highway 20 through Dubuque, Delaware, and Buchanan Counties is straightforward, as the historic highway parallels modern Highway 20 through the entire stretch. From Dubuque to Manchester, the road is designated Old Highway Road, Old Hawkeye Road, or Old Highway 20. It leaves Manchester on 210th Street, which turns south for one mile and becomes 220th Street. Subsequently, it becomes Iowa Highway 939, which it follows until Jesup. West of Jesup, the road is designated County D20, which becomes Independence Avenue as it approaches Waterloo. The small towns through which the highway passed were noted for their pleasant neighborhoods and business districts and for buildings with architectural and historic significance, including St. Francis Basilica in Dyersville, the courthouse in Manchester, and the Wapsipinicon Mill in Independence.

MISSISSIPPI RIVER BRIDGES, DUBUQUE. During the early decades of Federal Highway 20, the Wagon Bridge (above) carried animal, motor, and pedestrian traffic over the Mississippi River between East Dubuque, Illinois, and Dubuque, Iowa. Completed in 1887, this bridge served for 56 years until 1943, when the Julien Dubuque Bridge (below) opened. The railroad bridge at the right of the Wagon Bridge opened in December 1868. The Wagon Bridge was high enough for riverboats to pass underneath, whereas a section of the railroad bridge rotated 90 degrees to allow boats to pass. The Julien Dubuque Bridge was constructed to facilitate movement of troops during World War II and was painted gray to make it less visible in case of an enemy attack. The bridge is a National Historic Landmark.

THE ORIGINAL TOLL STATION, IOWA SIDE OF THE JULIEN DUBUQUE BRIDGE, DUBUQUE.
Bonds financed the Julien Dubuque Bridge, and a toll was charged from 1943 until the debt was paid in full in 1954, which was 11 years earlier than originally projected. This photograph, looking east, was taken in approximately 1950. The directional sign on the right indicates the route to Chicago, straight ahead on Highway 20.

MISSISSIPPI RIVER STEAMBOAT, DUBUQUE. Dubuque was a major port on the Mississippi River connecting the tristate region, Iowa, Wisconsin, and Illinois, to ports up and down the river. Persons crossing the Wagon Bridge and the later Julien Dubuque Bridge frequently were treated to views of the majestic ships on the river below.

Monument at Grave of Julien Dubuque, Overlooking Mississippi River near Dubuque, Iowa

JULIEN DUBUQUE GRAVE, DUBUQUE. Julien Dubuque died in 1810 and was buried with tribal honors by the Mesquakie Indians. In 1897, the monument shown on this card was constructed to mark his grave on a high bluff overlooking the Mississippi River and the land he had mined. The cylindrical tower is 25 feet high and 12 feet in diameter. A rough-hewn stone lies on the floor above the tomb.

THE OLD DESERTED SHOT TOWER, DUBUQUE, IOWA

THE OLD SHOT TOWER, COMMERCIAL STREET AT THE MISSISSIPPI RIVER, DUBUQUE. The historic Shot Tower dates to 1856. The 120.5-foot tower was used to manufacture lead shot for the Union army. Lead mined in the area was melted and poured through various-sized screens where it formed into round balls as it fell into cooling vats below. At its peak, six to eight tons of lead shot were produced daily.

ST. RAPHAEL'S CATHEDRAL, DUBUQUE.
After crossing the Mississippi River, historic Highway 20 turned right (north) on Locust Street where it passed St. Raphael's Cathedral. The cornerstone of the church was laid in 1857, and the first Mass was celebrated on Christmas Day of that year. The celebrant was Mathias Loras, the first bishop of the Dubuque diocese and the namesake of nearby Loras College.

FOURTH STREET ELEVATOR, DUBUQUE.
Also known as the Fenelon Place Elevator, this conveyance claims to be the shortest and steepest railway in the world. Dubuque's topography consists of flatlands near the Mississippi River with residential districts located on high bluffs. The elevator rises 296 feet from its lower terminus, and since opening in 1882, it has quickly and conveniently delivered residents to their homes above.

VIEW FROM ATOP THE FOURTH STREET ELEVATOR, DUBUQUE. For years, tourists have flocked to the Fourth Street Elevator for the thrilling ride up the steep hillside and for the spectacular view of the Mississippi River and downtown Dubuque. The entire Port of Dubuque is visible, as is the spire of St. Raphael's Cathedral. The graceful Julien Dubuque Bridge spans the river in the distance.

JULIEN DUBUQUE HOTEL, MAIN AND SECOND STREETS, DUBUQUE. A hotel has occupied this location in downtown Dubuque since 1839, although the building shown on this card opened in 1914 after the original Julien House burned down. Like many hotels throughout the Midwest, the Julien Dubuque Hotel is rumored to have been a haven for gangster Al Capone while he was lying low from the law.

KRETZ CAFETERIA, 496–498 MAIN STREET, DUBUQUE. From the time that it opened in 1934 through the early 1950s, Kretz Cafeteria was one of the most popular eating establishments in Dubuque. The owners touted it as the "most beautiful cafeteria in the central states. Famous throughout the nation for wonderful food." Diners could choose a table or booth on the main level or be seated on the more private balcony.

MAIN STREET, DUBUQUE. Anchored by Main Street, together with its adjacent streets and interconnecting avenues, Dubuque's business district was a lively place to shop and greet one's friends in the 1940s when this postcard was produced. One-way streets had arrived, adding safety and convenience for commuters and pedestrians alike. Many of the expected businesses are visible, including a restaurant, 5 & 10 store, drugstore, shoe store, and bank.

KARIGAN'S RESTAURANT, FOURTH STREET AND CENTRAL AVENUE, DUBUQUE. Brothers Constantine and Theodore and their cousin Andrew Karigan opened Karigan's restaurant in downtown Dubuque in 1940. The exterior and especially the interior of the restaurant featured the popular Art Deco style of the day. "Good food is the secret of our success," the restaurant's motto, is printed on the back of the card.

COUNTY COURTHOUSE, 720 CENTRAL AVENUE, DUBUQUE. Built in 1891, the ornate Dubuque County Courthouse is among the most dominant landmarks in northeastern Iowa. The architect, Fredelin Herr, chose the Beaux-Arts style with elaborate detailing to create this unique building. The four facades are topped by a 190-foot central tower and cupola, which in turn supports a 14-foot bronze statue of Lady Justice.

POST OFFICE AND FEDERAL BUILDING, LOCUST AND SIXTH STREETS, DUBUQUE. Designed to house both the post office and federal courthouse, the cornerstone was laid in 1932, and the building was occupied in 1934. Its location adjacent to Washington Park was specifically intended to incorporate the government center with businesses surrounding the park. This building is a prominent component of Dubuque's Cathedral Historic District.

ROSHEK BLOCK FROM CITY PARK, LOCUST AND SEVENTH STREETS, DUBUQUE. Before the emergence of regional malls and big-box stores, almost every city of reasonable size boasted a family-owned downtown department store. In Dubuque, Roshek's store fulfilled the needs of area shoppers. Founded in 1929, the nine-story Roshek's department store at one time was the largest in Iowa.

CARNEGIE-STOUT PUBLIC LIBRARY, ELEVENTH AND BLUFF STREETS, DUBUQUE. The imposing public library was endowed by a $60,000 grant from Andrew Carnegie. Local entrepreneur Frank D. Stout donated land for the building, and an additional $25,000 was raised by the Young Men's Literary Association to support the project and purchase books. Construction began in 1901, and the free public library has served the community continuously since 1902.

THE ELEVENTH STREET ELEVATOR, DUBUQUE. Farther north along Locust Street, Highway 20 passed the Eleventh Street Elevator, which began transporting riders from the high bluff above into Dubuque's business district below in 1887. Never as popular as the Fourth Street Elevator, it ceased operation in 1929. The signature feature of the Eleventh Street Elevator was its tunnel through the large limestone arch, which enabled traffic to pass unimpeded on the street above.

KEANE HALL, LORAS COLLEGE, LORAS BOULEVARD, AND ALTA VISTA STREET, DUBUQUE. Highway 20 served persons coming east or west to visit or study at any of Dubuque's three four-year liberal arts colleges. Loras College was founded in 1839 as both a seminary to prepare Catholic priests and a source of higher education for citizens of the area. Keane Hall, built in 1913, is considered the "Face of Loras College."

CLARKE COLLEGE, 1550 CLARKE DRIVE, DUBUQUE. Clarke College was founded in 1843 as a school for young Catholic women. It moved to its present location in 1881. Originally named Mount St. Joseph Academy, it attained four-year, degree-granting status in 1913 and, in the same year, was renamed Clarke College in honor of its founder, Mother Mary Frances Clarke. Clarke College's beautiful campus is shown on this card.

PETER'S COMMONS, UNIVERSITY OF DUBUQUE, 2000 UNIVERSITY AVENUE, DUBUQUE. Originally a theological seminary to train Presbyterian ministers for newly established communities in the tristate region surrounding Dubuque, this institution traces its history to 1852. It now is a four-year liberal arts university offering both baccalaureate and advanced degrees. The school moved to its present location in 1907. The building shown on this card is the student activities center.

GRANDVIEW TOURIST CAMP, DUBUQUE. When this card was produced in the 1920s, Grandview Avenue was near the western city limits of Dubuque. The tourist camp would have been an ideal location for a traveler to stop while on a motor trip on Highway 20. The pleasant tree-shaded site provided a comfortable place to relax. Here, a group of tourists appears to be enjoying a picnic.

Post Office Building, Epworth, Iowa

POST OFFICE BUILDING, EPWORTH. Epworth lies on historic Highway 20 approximately 12 miles west of Dubuque. The town was founded in 1855 and named after Epworth, England, the birthplace of John Wesley, the founder of the Methodist Church. Typical of many rural communities, the post office was the place where townspeople gathered to catch up on the news of the day. Note the unpaved Main Street.

Entrance to Seminary Grounds, Epworth, Iowa

SEMINARY GROUNDS, MAIN STREET, EPWORTH. In keeping with its Methodist origin, shortly after the town's founding, a seminary was established in Epworth to prepare Methodist clergy for ministries throughout the Midwest. The campus was acquired by the Society of the Divine Word in 1931, and the seminary transitioned into the preparation of Roman Catholic missionaries.

FARLEY STATE BANK, MAIN STREET, FARLEY. The presence of a well-functioning bank was the sign of success that many early-20th-century communities strove to achieve. The Farley State Bank ably fulfilled that role in this small western Dubuque County town. The bank was an anchor establishment on Main Street and a source of support for other businesses and farmers in the area.

THE RAINBOW COURT MOTEL, FARLEY. Even a town with a population less than 700 could have its own motel in the 1940s. The Rainbow Court Motel was modest but certainly provided motorists with the comforts of the day. Modern, in the 1940s, typically meant flush toilets in the cabin and innerspring mattresses. Some provided community cooking facilities in a separate building.

DYERSVILLE PARK, DYERSVILLE. During the 1940s and 1950s, town team baseball and softball games were popular attractions throughout the Midwest. Dyersville was a leader in the sport, and every summer Dyersville Park's lighted field and location directly on Highway 20 made it a favorite venue for exciting tournaments that attracted teams and fans from throughout northeast Iowa.

MAIN STREET, LOOKING EAST, DYERSVILLE. Dyersville's Main Street was typical of many communities in the 1920s. Change in the mode of transportation was evident from the cars parked on the street and, even more so, from the two businesses featured prominently on the card. Both the Ford dealership and the Iowa Oil Company derived their livelihood from the expanding automobile industry.

GERMAN STATE BANK, 301 FIRST AVENUE E, DYERSVILLE, IOWA. The architecture of many early-20th-century banks conveyed strength and security. The imposing front facade of this Main Street building must have convinced the sender of this card that the German State Bank fulfilled that objective. He told his correspondent, "Here is the place to put your money!"

ST. FRANCIS XAVIER BASILICA, DYERSVILLE. This Gothic-style church was completed in 1888 and can accommodate 1,300 worshipers. Pope Pius XII elevated the church to the status of basilica in 1956. Dyersville is one of the smallest towns in the United States that, in accordance with Vatican protocol, is eligible to host a Mass celebrated by the pope. The basilica is listed in the National Register of Historic Places.

GARRETT'S MILL, EARLVILLE. The small community of Earlville is located just south of historic Highway 20 between Dyersville and Manchester. Garrett's Mill and its adjacent millpond, fed by Plum Creek, provided residents of the community with a "picture-postcard" scene of rural tranquility.

FARM SCENE, EARLVILLE. The scene depicted on this card certainly was not typical of most postcards of the 1920s and 1930s. Rather than the usual scenic vista or a significant community building, it featured a sow and her hungry litter, a product upon which the economy of the area depended. No specific location of this farm is provided, but a notation on the back simply says, "Near Earlville."

THE DELAWARE COUNTY COURTHOUSE, MANCHESTER. This most notable landmark in Delaware County is located at 301 East Main Street in Manchester. It was dedicated on January 7, 1895, and has been home to the county's governmental agencies for more than a century. The walls of the redbrick building are 18 inches thick, and the tower and spire rise to a height of 135 feet. Seven hundred county citizens contributed money to buy the clock that was placed in the tower. Their names are recorded on a plaque on the first floor of the building. The original metal ceiling and much original woodwork can still be viewed within the building. The courthouse is listed in the National Register of Historic Places, and a memorial honoring all Delaware County veterans is located on the grounds.

MAIN AND FRANKLIN STREETS, MANCHESTER. Main Street, running east and west, carried historic Highway 20 through the center of Manchester. The junction with north-south Franklin Street was the main intersection and the center of Manchester's business district. A traffic signal in the center of the intersection was common during the early years of automobile travel. As traffic increased, they were moved to the corners of the intersections or suspended from wires overhead. The historic Delaware County Courthouse can be seen in the distance in the picture above, and the arrow at left center of this picture points to the Glen Charles hotel described in the next postcard. The Western Auto and Rexall Drugstores, shown in the photograph below, were stalwarts in most small-town business districts.

HOTEL GLEN-CHARLES, MANCHESTER, IOWA

GLEN CHARLES HOTEL, 222 SOUTH FRANKLIN STREET, MANCHESTER. Guests at this hotel, located just south of Highway 20, could take their meals at the hotel's English Grill, visit the Borden's Ice Cream Parlor next door, or simply watch the world go by on one of the chairs provided in front of the hotel. The cars in the picture are from the early 1930s.

MAIN STREET BRIDGE, MANCHESTER. The two-lane, steel girder bridge shown on this postcard carried traffic across the Maquoketa River for many years, including the early years of Highway 20. This 1930s view, looking east, shows the road approaching the bridge and the downtown business district. The historic Delaware County Courthouse is farther down the street. Note the Highway 20 sign on the right side of the street.

WEBBER'S BOAT LANDING AND THE MAQUOKETA RIVER, MANCHESTER. The Maquoketa River, both north and south of Manchester, provided the population with ample water activities. During the summer, canoeing, motor boating, fishing, and swimming all had their enthusiasts who took full advantage of the river. Access to the river was convenient due to well-maintained boat landings (above). A moonlight boat ride on the placid river (below) was a treat, and the thick foliage along the riverbanks was habitat for many birds and small animals, which could be observed most clearly from the river. In winter, many sections of the river were cleared for ice-skating, and inveterate fishermen bored holes through the ice and pursued their hobby undeterred by the cold weather.

MASONVILLE GARAGE, MASONVILLE. Masonville is located a half mile north of historic Highway 20 between Manchester and Independence, Iowa. This card is undated, but the car is reminiscent of the era covered in this book. The message on the back states that this beautiful Ford station wagon was typical of the dozens of brands of early body styles built on the Model A chassis from 1928 to 1931.

AIR VIEW, BUSINESS DISTRICT, AND ILLINOIS CENTRAL RAILROAD, WINTHROP. This air view of "The Friendliest Town for Miles Around" was taken from directly above historic Highway 20. The Illinois Central Railroad and Winthrop's Main Street course from left to right across the center of the picture. Although historic Highway 20 cannot be seen, it is located just off the lower border of this photograph, adjacent to the baseball field.

PEOPLE'S HOSPITAL, 801 FIRST STREET, INDEPENDENCE. The house at the left in this picture was the home of Capt. Daniel Lee, the first mayor of Independence. The house was converted into the town's hospital, and subsequently, the "modern" addition was added. When a new hospital was built, the addition was removed, but the Lee Mansion still remains. It is listed in the National Register of Historic Places.

PINICON HOTEL, 109 FIFTH AVENUE, INDEPENDENCE. The Pinicon Hotel, located near the junction of Highways 20 and 150, was built in the late 1940s to accommodate visitors to the city after the historic Gedney Hotel burned down in 1943. For many years, the Pinicon's coffee shop and restaurant were popular gathering spots enjoyed by hotel guests and community residents. The building was demolished in 2012.

BUCHANAN COUNTY COURTHOUSE, 205 FIFTH AVENUE, INDEPENDENCE. The three-story Buchanan County Courthouse was built in the 1940s and was designed in the popular Art Deco style of the day. The building has a symmetric front facade extending from the central door to mirror-image wings on either side. The building housed county offices, a courtroom, jail, and the office and apartment for the county sheriff.

THE "NEW" CITY HALL, MAIN STREET AND FOURTH AVENUE, INDEPENDENCE. The building shown in this picture is still used for its original purpose—housing the administrative offices of the City of Independence. The double doors at the rear lead to the municipal fire station that was added in the 1940s. Two signs on the corner of the building point to the ladies' restroom, also at the rear.

Gedney Hotel, Independence, Iowa

GEDNEY HOTEL, SECOND STREET, INDEPENDENCE. Charles Williams, a successful racehorse owner who had developed the renowned Rush Park racetrack one mile west of Independence, built the three-story Gedney Hotel and adjoining opera house in the 1890s. Rush Park became known in racing circles as the "Lexington of the North," and the internationally famous stallions Axtell and Allerton set world trotting records there. The hotel was equipped with the latest amenities of the day to accommodate sportsmen who came to Independence from throughout the country. Williams even built an electric trolley to transport guests from the hotel to the track. Interestingly, the first sub-two-minute mile on a bicycle was accomplished at Rush Park. The Gedney Hotel burned down in 1943, taking with it a huge block of Independence history.

MAIN STREET, LOOKING WEST, INDEPENDENCE. Like many county seats in rural America, Independence was the shopping destination for miles around. In this 1930s-era picture, there does not appear to be a parking space available on either side of Main Street. An amenity for pedestrians, and sometimes for local dogs, was the water bubbler on the sidewalk in front of the bank on the left side of the street.

MAIN STREET, LOOKING EAST, INDEPENDENCE. This picture, taken approximately 10 years after the previous photograph, shows Main Street looking east. Traffic continued to be heavy, and many shoppers were walking from store to store along the street. Note that the pattern of parking had changed from diagonal to parallel, increasing the width of the traffic lanes.

TWO MAIN STREET BRIDGES AND MILL DAM, INDEPENDENCE. The two-span, steel girder bridge in the picture above carried traffic over the Wapsipinicon River for several years prior to the street being designated Highway 20. The new concrete arch bridge, pictured below, opened in 1917 and has carried Highway 20 traffic for almost a century. Its construction was an engineering marvel, as the arches and deck of the former bridge continued to carry traffic during construction of the new bridge. The old steel arches supported the superstructure for the new bridge, and the original deck served as the construction platform as well as the traffic corridor while the new bridge was built. The dam, constructed in 1854, provided energy to the Wapsipinicon Mill on the west bank of the river and later to the electric power station on the east bank.

OLD MILL, BRIDGE AND DAM, INDEPENDENCE, IOWA

THE WAPSIPINICON MILL, 101 MAIN STREET WEST, INDEPENDENCE. The Wapsipinicon Mill is among the most significant buildings on historic Highway 20 in Iowa. The mill and adjacent dam began operation in 1854. The redbrick structure is 122 feet long by 62 feet wide. The superstructure and interior show superb craftsmanship, including hand-hewn timbers, mortise and tenon joints, square nails, and wooden pegs. The original purpose was to mill flour, but in keeping with evolving economic conditions, production was later changed to poultry and stock feed. The mill operated until the mid-20th century, and the original millstones and much original machinery can still be viewed. Now operated by the Buchanan County Historical Society as a hands-on museum, it is listed in the National Register of Historic Places and has been declared one of Iowa's 10 most important historic sites.

WAPSIPINICON RIVER AND DAM, INDEPENDENCE. Producing power for both milling and electricity was the primary function of the Wapsipinicon dam, but it also enabled greater use of the river by the population. The placid water above the dam was ideal for swimming, boating, fishing, and simply enjoying its scenic attractiveness, as shown in this view taken from the Main Street Bridge.

CITY PARK AND BOAT LANDING, INDEPENDENCE. The small park along the riverbank behind the Wapsipinicon Mill provided a pleasant site for a picnic or a place to launch a boat. Boaters were kept away from the dam by a cable attached to a series of metal drums extending across the river.

UNION BUS DEPOT, CORNER OF MAIN STREET AND SECOND AVENUE, INDEPENDENCE. Construction of better highways and the concurrent decline of passenger train service during the 1930s and 1940s resulted in bus transportation becoming increasingly more popular. In most small towns, including Independence, the local bus station (above) provided not only a location for arriving and departing passengers, but also a gathering place for the local population. The well-stocked coffee shop (below) was a small but busy enterprise. Independence was served by both the Jefferson Lines and Iowa Coaches, which connected with other carriers in larger cities nearby. Reflective of the times, cigarettes received top billing on the placard above the door.

COLONIAL MOTEL, WEST MAIN STREET, INDEPENDENCE. The main building of this motel dates to the 1880s and was a stagecoach stop in the new community of Independence. In the 1930s, several individual cabins were added to accommodate tourists on Highway 20. Local legend says that stagecoach robbers on the run hid their haul in a well that now lies under the flower bed in the parking lot.

CHICAGO, ROCK ISLAND & PACIFIC RAILROAD DEPOT, WEST MAIN STREET, INDEPENDENCE. This redbrick station house was the hub for north-south passenger and freight service provided by the Chicago, Rock Island & Pacific Railroad in Independence throughout the first half of the 20th century. Later, the building fell victim to the decline in the popularity of railroads, and it was demolished to make room for other businesses along the Highway 20 corridor.

Rush Park Motel, Highway 20 West, Independence. This motel is named for the famous racetrack that once occupied the site. During the early years of Highway 20, barns and several outbuildings existed. Now, only the original owner's mansion and one outbuilding remain, the latter having been converted to a tavern. This motel, a mobile home park, school, fast-food restaurants, and other businesses occupy the remainder of the property.

State Hospital, Highway 20 West, Independence. This hospital opened in 1883. Originally named the Iowa Hospital for the Insane, it was intended for treatment of alcoholics, drug addicts, the mentally ill, and the criminally insane. During the 1930s and 1940s, approximately 1,800 patients resided at the hospital daily, many for lengthy periods, as treatment modalities were limited. The hospital is located on 300 beautifully landscaped acres one mile south of historic Highway 20.

XL Motel, Sixth and Prospect Streets, Jesup. The motto of this small roadside accommodation, "The Motel that Excels," is incorporated into its name. Guests could count on clean, attractive, and restful rooms with baseboard heating and free radios, all offered at reasonable rates. Flowers at the base of the building and chairs by each unit enhanced the motel's comfort.

Business Section, Jesup. Historic Highway 20 coursed east-west across Iowa, but in Jesup, it proceeded north-south through the town on Sixth Street. Young Street (business section) was situated perpendicular to the highway and parallel to the Illinois Central Railroad tracks. Typical of most small Midwestern towns, storefront buildings lined the street and sold the commodities of the day. Several 1930s-era automobiles are parked near the tavern, featuring Budweiser beer.

ILLINOIS CENTRAL RAILROAD DEPOT, CITY PARK, AND GAZEBO, JESUP. The city park in Jesup extends for one block both east and west of historic Highway 20 in the center of town. It is bounded on the south side by the Illinois Central Railroad tracks and the north side by Young Street. As in many communities, the railroad depot (above) was a center of activity. The arrival and departure of trains was an exciting event, especially for children. The City Park (below) was a pleasant place where people could relax and possibly listen to a band concert while waiting for the trains to arrive. The depot shown in these photographs has been gone for several years, but the gazebo, or its reincarnation, still exists.

Two

The Cedar and Iowa River Valleys

The Cedar and Iowa River valleys encompass Blackhawk, Grundy, Butler, and Hardin Counties. Early travelers were treated to views of some of Iowa's most productive farmland while passing through this region, although much of Blackhawk County was dominated by the cities Waterloo and Cedar Falls. In 1926, when Highway 20 was new, these communities were separated by several miles. They now have evolved into a unified metropolitan area, but each city maintains its individual identity. Waterloo was a center for meatpacking and the manufacture of farm equipment, whereas Iowa State Teacher's College made Cedar Falls an educational center. Historic Highway 20 remained east of the Cedar River while coursing northwest through Waterloo, but many travelers chose to divert the short distance to visit the stores, hotels, and restaurants in both the east and west side business districts. The Cedar Falls business district was conveniently located, extending south on Main Street from the Highway 20 (now Iowa 57) intersection near the Cedar River.

From the early 20th century, Waterloo's Electric Park and National Dairy Cattle Congress attracted visitors to the area, many arriving via Highway 20. The former was one of the first electrified amusement parks in the country. It provided entertainment until the 1940s, when changing tastes of the population forced its closure. The National Dairy Cattle Congress has been held annually since 1910. Primarily an agricultural exposition, its coliseum has been a venue for conventions, trade shows, and athletic events throughout the years.

Continuing west, historic Highway 20 was the connecting link between several smaller towns, including New Hartford, Parkersburg, Aplington, and Ackley. A few miles northeast of Iowa Falls, historic Highway 20 joined US Highway 65 and entered the city from the north where it passed by Ellsworth Community College before turning west and crossing the beautiful Iowa River. West of Iowa Falls, historic Highway 20 is now County D20. The road provides views of the scenic Iowa River from the highway bridges and glimpses of roadside villages Alden and Austinville before leaving Hardin County.

Wagon Wheel Motel

PHONE 2-4687

Every Room Modern with Shower & Floor Radiant Heat

1½ Mile East on 20 WATERLOO, IOWA Mr. & Mrs. ALLEN J. PEVERILL Owners

WAGON WHEEL AND REST WELL MOTELS, HIGHWAY 20 EAST, WATERLOO. Prior to modern Highway 20 being rerouted south of Waterloo, most westbound travelers entered the city on Independence Avenue (historic Highway 20). These two small motels were located just east of the city limits. Both pictures show the motel units adjacent to the owners' homes, no doubt as a means of supplementing the income of the resident families. The Wagon Wheel boasted of its excellent radiant floor heating and a rating of very, very good by the AAA. The Rest Well offered a children's playground and soft water, and radios were available.

REST WELL MOTEL, HIGHWAY 20 EAST, WATERLOO, IOWA

ST. FRANCIS HOSPITAL WATERLOO, IOWA

ST. FRANCIS HOSPITAL, INDEPENDENCE AVENUE, WATERLOO. Founded in 1912 by Franciscan sisters, throughout the first half of the 20th century, this 240-bed hospital was a significant provider of medical services for Waterloo, Cedar Falls, and surrounding communities. As medical care advanced, the building could no longer provide the needed services, and it merged with another nearby hospital. This building still exists and has been remodeled for other purposes.

GRACE METHODIST EPISCOPAL CHURCH, WATERLOO, IOWA.

GRACE METHODIST EPISCOPAL CHURCH, 633 WALNUT STREET, WATERLOO. This large and distinguished building has been a fixture in Waterloo since the early 1900s. It is located one block east of historic Highway 20 and is clearly visible from the highway. It is now known as the Mount Moriah Baptist Church.

45

ELLIS HOTEL AND BISHOP'S CAFETERIA, 210 EAST FIFTH STREET, WATERLOO. The postcard above showing the Ellis Hotel was mailed on July 29, 1927, only one year after Highway 20 received federal designation. Located at East Fifth and Sycamore Streets east of the Cedar River, the Ellis remained a popular hotel during the early years of Highway 20. The guest rooms contained all the amenities of the day, and much of the first floor housed the popular Bishop's Cafeteria, shown more fully at left. This landmark cafeteria was opened by Benjamin Franklin Bishop in 1920. It served guests of the hotel as well as local residents until 1970, when it moved to a new location in a shopping center. The cafeteria was noted for the quality of its food and its generous servings.

HOTEL PRESIDENT, 500 SYCAMORE STREET, WATERLOO. The 200-room Hotel President was a favorite location in Waterloo's commercial district on the east side of the Cedar River. All public and guest rooms were fireproof, and the latter were furnished with private baths and contained the most up-to-date appointments. The hotel's famous Zephyr Grill was considered to be one of the finest dining destinations in the region.

LINCOLN PARK, WATERLOO. This attractive park on Waterloo's east side was near the popular hotels, restaurants, and shopping. East Franklin Street, the route of historic Highway 20, formed its eastern border. The park provided a pleasant place for shoppers and workers alike to relax or enjoy an alfresco lunch. The intercity bus station was located just across the street, and many persons awaiting the buses took advantage of the park.

Black's Bldg.,
Waterloo, Ia.

JAMES BLACK DRY GOODS COMPANY, EAST FOURTH AND SYCAMORE STREETS, WATERLOO. Black's company was founded in 1892, and from its humble beginning as a small storefront shop, it grew into one of the largest and most complete department stores in Iowa. The company moved to the building shown in the picture at left in 1914. The picture illustrates that Black's was easily accessible by both automobiles and streetcars. The lounge, shown in the picture below, was located on the mezzanine floor and was appointed with comfortable furniture. It provided a welcoming space for tired shoppers to catch their breath before heading home. An interesting feature of the store was the system of pneumatic tubes that carried transactions between sales counters and cashiers. Children especially were fascinated by the rapidly moving capsules that looked very much like mice scooting through the tubes!

REST ROOM, MEZZANINE FLOOR, THE JAMES BLACK DRY GOODS CO., WATERLOO, IOWA.

East Fourth Street, Looking West, Waterloo. A small section of Lincoln Park appears at the right in this picture, and Black's Department Store is shown in the next block. Fourth Street continued on across the Cedar River to Waterloo's west side business district and residential neighborhoods. It was a common route for drivers arriving on Highway 20 to follow when visiting various locations within the city.

New Park Avenue Bridge, Waterloo. This attractive bridge over the Cedar River was one of several that intersected with historic Highway 20 at Franklin Avenue, connecting Waterloo's eastern and western business districts. The 615-foot-long bridge was dedicated in 1939 and cost $205,000 to build. The writer of this card said they had driven 539 miles and were ready to spend the night in Waterloo.

49

RUSSELL-LAMPSON HOTEL AND LOBBY, 209 WEST FIFTH STREET, WATERLOO. Highway 20 motorists who had occasion to visit west Waterloo frequently chose to stay at the Russell-Lampson hotel, built by Clyde Lampson and his wife, Lillian Russell. The hotel, shown in the photograph above, opened in 1914 at a cost of $350,000. The hotel's ornate lobby, featured in the photograph below, had a checkerboard tile floor, comfortable furniture, and both natural and artificial lighting. The 250-room hotel, with 150 baths, was state of the art, and for years, it served as a center of business and social activities in the city.

ELECTRIC PARK, WATERLOO. The advent of electric lights spawned the formation of many amusement parks throughout the country, including Electric Park, Luna Park, and White City Park. Most were accessible by trolley as well as by automobile. Waterloo's Electric Park attracted visitors from throughout the region who enjoyed the attractive grounds and exciting rides, including the giant swing, a unique water-driven Ferris wheel, and the daring Spiral Thriller roller coaster.

DAIRY CATTLE CONGRESS, AIR VIEW, WATERLOO. Since beginning in 1910, the size to which the National Dairy Cattle Congress had grown is illustrated in this 1940s postcard. Many barns, the hippodrome, and extensive parking met the needs of the animals and the more than 250,000 annual visitors. The Dairy Cattle Congress has always lived up to its early slogan, "Congress entertainment is educational; its education is entertaining; it is ALL inspirational."

HIPPODROME, DAIRY CATTLE CONGRESS, WATERLOO. The steel and concrete hippodrome, built in 1919 and renovated in 1936, continues to be the largest building on the Dairy Cattle Congress grounds and the most used. In addition to being the focal point during the Cattle Congress, the building's seating capacity of more than 8,500 has been ideal for concerts; sporting events, including basketball and hockey; rodeos; and other activities throughout the years.

SHOW RING, DAIRY CATTLE CONGRESS, WATERLOO. A highlight of the Dairy Cattle Congress each year was the Parade of Champions held in the Hippodrome. Inclusion in this event was a significant accomplishment for the animals' owners. In this 1940s card, the best-of-the-best were featured in the center ring to the enjoyment of a full house of cheering spectators.

McCormick-Deering Band, Waterloo. Dairy Cattle Congress activities included dances and other social events that contributed to the fun of the occasion. The back of this card says, "Les Hartman and his McCormick-Deering Band as they appeared at the International Harvester exhibit, Dairy Cattle Congress, Waterloo, Iowa, 1938." McCormick-Deering was the trademark name for a line of tractors and farm machinery manufactured by the International Harvester Company.

Airline Motel, Highways 20 and 57 between Waterloo and Cedar Falls. Proximity to the Waterloo-Cedar Falls Municipal Airport, less than two miles distant, accounts for the name of this motel. The guest rooms provided hot water heat, air-conditioning, and room phones. An indication of this card's era states that television was "available," probably in a central location, such as the motel's office.

53

WATERLOO MUNICIPAL AIRPORT AND CONVAIR ROOM, HIGHWAY 20, WATERLOO. This airport, located between Waterloo and Cedar Falls, was the hub for air services in north central Iowa. The photograph above shows the terminal building and a Mid-Continent DC3 plane on the tarmac. Mid-Continent was formed in the 1930s and served many smaller cities throughout the Midwest beginning with mail service and eventually evolving into a passenger carrier. It continued in operation until merging with Braniff Airlines in 1952. The back of the postcard above mentions specifically the Convair Dining Room, shown in the photograph below, located in the terminal building. The name was derived from Mid-Continent's Convair airplane fleet, a newer and larger passenger plane that succeeded the DC3s.

TOURIST PARK, CEDAR FALLS. Ample camping spaces and plenty of shade were features of this tourist park along the Cedar River. The writer of this card in 1932 was more interested in his farm. He reported that they had a good crop of hay and potatoes and had sold 60 pigs and 10 cartons of eggs! After much hard work, possibly they were relaxing in this pleasant park.

BATHING BEACH AND AUTO TOURIST PARK, CEDAR FALLS. Swimming in the river was common in many communities before swimming pools were available. This Cedar River bathing beach was a hub of summertime activity in the 1930s when this card was published. The sandy beach and several rafts contributed to the enjoyment of the river. The white building contained dressing rooms and refreshment stands.

ICE HOUSE MUSEUM, US HIGHWAY 20 AND 218, CEDAR FALLS. Construction of the Cedar Falls Ice House was begun in November 1921, less than one week after its predecessor, a wood-frame building from 1858, burned to the ground. The building is 100 feet in diameter with walls 30 feet high. It had the capacity to hold 6,000 to 8,000 tons of ice harvested from the nearby Cedar River. After the ice industry declined, the building was used for a livestock sales pavilion, an ice-skating rink, and boat storage, but eventually it fell into serious disrepair and was condemned. In 1976, the Cedar Falls Historical Society and the local newspaper launched a drive to save this landmark as a museum. The building now houses displays on the natural ice industry and early agriculture. It is listed in the National Register of Historic Places.

RIVERVIEW PARK, CEDAR FALLS. Planning for the Riverview Park Evangelical Grounds began in 1921 as a joint effort between the Cedar Falls Commercial Club and local clergymen with the intent to bring spiritual enrichment to the community. The first conference was held in 1922. Over the years, the conference attracted huge crowds, many arriving by car on Highway 20.

CEDAR RIVER FROM RIVERVIEW PARK, CEDAR FALLS. This postcard illustrates the scene along the Cedar River that is responsible for the name Riverside Park. The wooded shoreline and gently flowing river provides an aura of peace and tranquility as it flows past the park. The dome roof of the Cedar Falls icehouse located directly on historic Highway 20 can be seen in the distance.

MAIN STREET, CEDAR FALLS. This mid-1920s postcard provides a picture of Main Street at the time Highway 20 was designated a federal highway. Main Street intersected with Highway 20 near the Cedar River, which, on this card, would be at the far end of the street. Trolley tracks were present, but the rising popularity of automobiles is evident. In true patriotic fashion, two flags were flying proudly.

CEDAR FALLS MOTEL, 1315 WEST FIRST STREET, CEDAR FALLS. A location on the main east-west highway through the city, and close to Iowa State Teachers College (ISTC), contributed to the popularity of this 1940s motel. Ample parking was available, and the well-manicured grounds and large picture windows gave the guest rooms a homelike atmosphere.

CAMPANILE, IOWA STATE TEACHERS COLLEGE, CEDAR FALLS. This Cedar Falls institution was founded in 1876 as a public school for training future teachers. It was originally named the Iowa State Normal School. In 1909, the name was changed to Iowa State Teachers College, which it retained until 1961, when the college acquired its present name University of Northern Iowa. The 1909 name change was coupled with the determination to establish a campus focal point, and efforts were undertaken to construct a campanile. Following a 13-year period of planning and fundraising, ground breaking for the landmark occurred in November 1924. The cornerstone was laid on June 1, 1925, bells were installed, and the inaugural recital was held on September 19, 1926. The cost of the project had risen from $12,000 to more than $50,000 during the intervening years.

THE COMMONS, IOWA STATE TEACHERS COLLEGE, CEDAR FALLS. This building opened in 1932 and was among the most prominent structures on the ISTC campus. It housed recreational spaces, including lounges, a ballroom, dining facilities, and reception areas. The Commons overlooked the large green that was central to the campus. The latter provided space for students to meet their friends as they walked to their various classes, or relax on the grass on a sunny day.

BARTLETT HALL, IOWA STATE TEACHERS COLLEGE, CEDAR FALLS. Bartlett Hall served as a women's dormitory from 1914 until 1942, when ISTC entered into an agreement with the War Department to provide basic training for women entering the armed services. The building and surrounding grounds became a boot camp for WAVES (female Navy personnel). This arrangement continued throughout World War II. Bartlett Hall reverted to its original purpose in 1945.

O.R. LATHAM FIELD, IOWA STATE TEACHERS COLLEGE, CEDAR FALLS. This stadium, named in honor of college president O.R. Latham, replaced the earlier stadium that had been destroyed by a tornado in 1936. Its seating capacity was 6,000 with the potential for additional temporary seating. Modern training facilities, a press box, and scoreboard were included. ISTC defeated Northeast Missouri Teachers College 12-0 in the inaugural game on September 23, 1939.

MAIN STREET, NEW HARTFORD. This postcard was published only a few years before Highway 20 was designated a federal highway, but it shows Main Street, which eventually would carry the road. This picture was taken in the early 1920s, and it appears the town was celebrating a special event. All the early automobile enthusiasts were showing off their "gas buggies."

THE ONLY TOWN ON THE MAP, PARKERSBURG. A map of the United States showing Parkersburg to be the only town amply demonstrated both civic pride and a sense of humor. Unfortunately, there is no indication on the card to identify its inspiration.

MODERN TOURIST COURT, HIGHWAY 20, PARKERSBURG. This early motel was later named the Burr Oak. It provided plenty of outside seating on the large shaded lawn, a welcomed location before air-conditioning was available. No doubt it was a favorite place for guests to relax after a long day's drive. A separate office and restaurant and the owner's home were included in the complex.

HOMES ON SOUTH MAIN STREET, PARKERSBURG. Most smaller communities along historic Highway 20 were characterized by pleasant residential neighborhoods on either side of the central business district. In Parkersburg, this tree-lined street with well-trimmed lawns was typical of that characteristic. The large porches were pleasant places to enjoy cool breezes on warm summer evenings.

MAIN STREET, PARKERSBURG. Main Street in Parkersburg was the center for shopping and other business activities, and most days found the street occupied by cars and pedestrians. Historic Highway 20 did not follow Main Street directly through Parkersburg but rather paralleled it a short distance to the west. Still it was the road many motorists followed on their way to the business district.

Beaver Creek Bridge, West Parkersburg, Iowa

BEAVER CREEK BRIDGE, ONE MILE WEST OF PARKERSBURG. Many roads in Iowa and across the Midwest were still unpaved when federal highways were designated in 1926. This card cannot be dated precisely, but there is no doubt that historic Highway 20 crossed this bridge and followed the route of this gravel road during its early existence. Note the plank flooring of the bridge's roadbed.

COWS IN THE CREEK, PARKERSBURG. Early postcard manufacturers produced generic cards showing scenes that were typical of several communities. This card represents that practice, and only the local postmark identifies it specifically with Parkersburg. The cattle in the picture are enjoying the cool waters of the creek, possibly below the bridge shown in the previous picture.

NORTH SIDE OF MAIN STREET, APLINGTON. Aplington derived its name from Fort Aplington, an Army post overlooking the Iowa River. The fort succumbed to fire in 1885, but the village around it continued to prosper. The name Fort Aplington was used until 1925 when "Fort" was dropped, and the present name of Aplington was adopted. The Standard service station served the local citizens and travelers on historic Highway 20.

VILLAGE MOTEL, HIGHWAY 20, APLINGTON. The design of this building was typical of many motels built in the 1940 and 1950s. Most likely the owner lived in the house at the left of the picture. When Highway 20 was the primary route through the area, the motel probably enjoyed a steady occupancy. Like many motels from this era, it has been converted to apartments.

TRIANGLE, ACKLEY. Ackley is located in the extreme northeast corner of Hardin County. Converging at an angle, three streets in the business district, namely Main and State Streets and Park Avenue, form the Triangle. This photograph from the 1930s shows the pleasant street scene with several cars parked at the curb. Before the days of traffic congestion many communities used diagonal parking.

MUNICIPAL BUILDING, CORNER OF STATE AND MAIN STREETS, ACKLEY. Travelers on Highway 20 (now Iowa 57) may have noticed a window washer hard at work when this picture of Ackley's Municipal Building was taken. The car parked at the curb dates the picture to the mid-1930s. The sign on the attractive corner lamppost informed drivers, "Business District, Speed Limit 20-Miles."

RESIDENCES, ACKLEY. This residential neighborhood street presented a picture of small-town life suitable for a movie. The mature trees and broad lawns surrounding the houses projected the feeling of serenity and stability. The only missing elements are a few picket fences and children on bicycles.

PUBLIC PARK, ACKLEY. Civic events in the local park were a popular form of entertainment during the early decades of the 20th century, and many towns boasted several throughout the summer months. The gazebo was the venue for various activities, including speeches, political rallies, and musical presentations. The park in Ackley was the perfect gathering place where local citizens met to enjoy socializing with their friends.

SCENIC CITY KABIN KAMP, IOWA FALLS. The back of this card describes this 1930s tourist camp as consisting of "Modern Cottages, Simmons beds, Artesian water, Cafe in connection, Home cooked food, Tourist supplies and Skelley Products," followed by a final quote, "A good home away from home." The sender of the card marked an "X" on the cabin she had occupied.

INTERIOR VIEW, SCENIC CITY MOTEL, HIGHWAYS 20 AND 65, IOWA FALLS. This later postcard shows that the Kabin Kamp had been converted into a more modern motel furnished in Art Deco style. Guests were assured of "year 'round comfort" in 32 units equipped with all the standard services expected in a modern motel, including telephone and a café. Television was listed, but none is evident in this room.

68

SWITZER'S MOTEL, HIGHWAYS 20 AND 65, IOWA FALLS. Switzer's was another small roadside establishment located a short distance north of Iowa Falls. The writer of this card described it as a very nice motel, and they had a good supper across the road. She reported awful winds, which made driving hard, but they expected to stay on Highway 20. Unfortunately, she did not say in which direction they were traveling.

ELLSWORTH COLLEGE, IOWA FALLS. Ellsworth College began as a business academy founded in 1890 through the generosity of Eugene Ellsworth who contributed the land and funding for the early buildings. Over the years, the institution evolved into a four-year liberal arts college and subsequently into Ellsworth Community College. It ranks among the finest community colleges in the country.

CARNEGIE-ELLSWORTH LIBRARY, 520 ROCKSYLVANIA AVENUE, IOWA FALLS. Iowa Falls was the fortunate recipient of two $10,000 Carnegie Foundation library grants, plus additional funding provided by Eugene Ellsworth. The library on this card served the public, and the Ellsworth College Library was located on campus. The first floor of both buildings is very similar, but the public library has classic arches and dome, whereas the college library has a full second floor.

CITY PARK, IOWA FALLS. Typical of many public squares throughout the country, the city park in Iowa Falls was highlighted by the bandstand and a cannon. Concerts played from the former were sources of enjoyment on summer evenings, and the latter honored citizens of the area who had served their country in earlier armed conflicts. Flower beds and benches added to the attractiveness of the park.

WASHINGTON AVENUE, IOWA FALLS. Historic Highway 20 entered Iowa Falls from the north and then turned west on Washington Avenue, passing through the Iowa Falls business district. The picture above was taken in the late 1920s and shows that business was brisk. Many cars were on the street and parked at the curb. The post in the middle of the street admonished drivers to stop and not make a U-turn. The picture below was taken a few years later when the street was much less busy. Before the era of shopping centers and competition from major chain stores, most small-town businesses were locally owned. The town's citizens expected the stores to be closed on Sundays and holidays, and they planned their shopping excursions accordingly.

PRINCESS CAFÉ, 607 WASHINGTON AVENUE, IOWA FALLS. This building is an outstanding example of Art Deco design from 1935. It was the first establishment in Iowa Falls to be air-conditioned, and for almost eight decades, it has been a gathering place for residents and visitors to the city. The building is listed in the National Register of Historic Places and continues to operate as a café and ice cream parlor.

HOTEL WOODS, IOWA FALLS. In 1856, Alfred Woods built the original Western House at Washington Avenue and Main Street. This 1940s card proudly points out that the foundations and walls of that building were incorporated into the present Woods Hotel and that there had been 84 years of continuous hotel service at this location. The Woods Hotel was destroyed by fire in 1992. Arson was suspected but never proven.

IOWA RIVER AND WASHINGTON AVENUE BRIDGE, IOWA FALLS. The lovely Iowa River and the two-span, concrete arch bridge are shown in both postcards. The bridge dates to 1933. It carried historic Highway 20 traffic through the center of the city and across the river since being commissioned to replace a steel bridge, which had served the community since 1911. At its dedication in 1934, Mrs. F.H. Cottrell, wife of the Iowa Falls mayor, described it as "a beautiful bridge over a beautiful river." The Washington Avenue Bridge has been in continuous use since then with only maintenance-related repairs. The City of Iowa Falls assumed ownership of the bridge in November 1995 when the new Highway 20 was routed south of Iowa Falls.

BEAUTY SPOTS OF IOWA, IOWA FALLS. The scenes on this card certainly live up to the title "Beauty Spots of Iowa, U.S.A." The first view shows boaters enjoying the Palisade's spectacular rock formations from the perspective of the Iowa River. The second view is of Wildcat Glen, another of the river's popular hiking and picnicking sites.

SNOW SCENE, HIGHWAY 20, WEST OF IOWA FALLS. The challenge of winter driving in Iowa is illustrated in this early-1930s card. The road had been plowed, and the snowbanks dwarfed the man in the picture. There is no information on the card to indicate the specific intention of the photograph. Possibly, the well-dressed gentleman simply wanted to illustrate that his shiny new car could handle an Iowa blizzard.

IOWA RIVER DAM, ALDEN. The Iowa River dam provided waterpower for producing electricity for the community but equally important was its contribution to the enjoyment of the local citizenry. The dam improved opportunities for fishing, swimming, and boating during the warmer months, and the Iowa climate enabled ice-skating in the winter. Paths along the riverbank were popular places to stroll throughout the year.

MAIN STREET, ALDEN. Grocery, drug, clothing, and hardware stores were Main Street fixtures in most rural communities, as were restaurants, taverns, and auto dealerships. Shopping centers were far in the future when this photograph was taken in the mid-1930s. Main Street was both a place to conduct business and the site of many social activities.

PUBLIC LIBRARY, ALDEN. Alden is the smallest community in the United States to receive a Carnegie Foundation library grant. The village's 699 population in 1900 was too small to qualify for an award, but persistent efforts by the citizens persuaded the grantors to make an exception. A $9,000 grant was approved. The library opened in August 1914 and is still in use. It is in the National Register of Historic Places.

VILLAGE CEMETERY, ALDEN. The village cemetery had unique appeal in many rural communities. The gravestones presented a history of the community and provided a record of persons who had been part of the community's fabric. Persons returning to the village typically visited the cemetery to remember an ancestor, and on Memorial Day and the Fourth of July, the cemetery was the venue to celebrate the lives of local military veterans.

Three

The Boone, Des Moines, and Raccoon River Valleys

The west-central section of Iowa, consisting of Hamilton, Webster, and Calhoun Counties, is the least populous of the regions through which historic Highway 20 passed. The population of most communities was less than 2,000 when the federal highway designation was applied in 1926. Webster City with approximately 6,000 residents and Fort Dodge with 20,000 were the two largest cities in that area of the state. These communities and the intervening smaller towns were surrounded by some of the most productive farmland in the Midwest, resulting in Iowa being a legitimate claimant to its title "Tall Corn State" and, together with neighboring Great Plains states, the distinguishing description, the Corn Belt.

Williams is the easternmost community in Hamilton County through which historic Highway 20 passed in this region. From there the road proceeded west, skirting the south edge of Blairsburg, and on to the county seat, Webster City, crossing the Boone River as it entered the city and following Second Street through the business district. Historic buildings included the Willson hotel and the nearby Hamilton County Courthouse, both of which are now gone. Several existing Webster City buildings are listed in the National Register of Historic Places, including the Kendall Young Library and the Webster City Post Office

Fort Dodge, the seat of Webster County, evolved from a fort built in 1850 on the Des Moines River but was abandoned by the Army in 1853. The property was purchased by a private citizen who founded the town, which became officially recognized in 1869. In addition to agriculture, Fort Dodge prospered from the gypsum deposits in the region. The block of gypsum from which the infamous Cardiff Giant was sculpted and foisted on gullible observers as a petrified human was mined near Fort Dodge. Farther west, historic Highway 20 passed tiny Moorland before reaching Rockwell City, which proudly proclaimed itself to be "the Golden Buckle of the Corn Belt." Rockwell City was the original home of the Iowa Women's Reformatory, which now is a minimum-security prison for men. The road continued on through Lytton before leaving Calhoun County.

MAIN STREET, WILLIAMS. Main Street in Williams was still gravel when this photograph was taken in the mid-1920s. The writer described his travel from Waterloo, through Cedar Falls and other small towns, before reaching Williams. It was raining, and the roads were awful. He had hoped to get to Fort Dodge, 38 miles farther, but still planned to go 168 miles to Sioux City the following day.

LUTHERAN CHURCH, WILLIAMS. The country church was a symbol of both religious commitment and stability in many small towns in the early 1900s. Some were served by itinerant preachers, and others had a permanent pastor who lived in the parsonage associated with the church. Many had a cemetery adjacent to the church.

BLU TOP MOTEL, HIGHWAY 20, WEBSTER CITY. This motel advertised that it provided 16 units with "Plenty of Shade and Vented Gas Heat." The grove surrounding the cabins confirmed the truth of the former promise. The cabins appear to be of different designs. The curved roof of a Quonset-style cabin is located at the left of the picture, and the cabin in the center is a more conventional tourist cottage.

KENDALL YOUNG PARK, 600 KENDALL YOUNG ROAD, WEBSTER CITY. Kendall Young Park is located in northeast Webster City, only one mile north of historic Highway 20. The park contained several shelters and picnic areas, which were available to local residents and travelers. The picturesque creek winding through the length of the park added to its relaxing atmosphere and provided a fishing opportunity for children.

STEEL GIRDER BRIDGE AND THE BOONE RIVER, WEBSTER CITY. A short distance east of Webster City, historic Highway 20 crossed the bridge shown on the postcard above, which spanned the scenic Boone River. The design of the bridge was typical of many along the highway in the Midwest. These bridges were strong and dependable and, with reasonable maintenance, could be expected to serve for many years. This bridge corresponded to the two-lane width of the highway and clearly was sufficient for the traffic of the day. A walkway was provided on one side of the bridge for the safety of pedestrians. The latter also served as a popular place for fishing. The placid river, shown in the picture below, was an ideal location for boating, swimming, fishing from the riverbank, or simply enjoying the beautiful scenery.

NOKOMIS TOURIST PARK, 225 EAST STREET, WEBSTER CITY. Tourists in Webster City could be accommodated at this pleasant park. The cars in the picture indicate an early-1930s date. Overnight cabins were available, but travelers with their own tents were welcome. The community facility in the center of the card was open to all. The sign nailed to the tree admonished motorists to "Drive Slow."

COURTHOUSE PARK, WEBSTER CITY. This park, located adjacent to the Hamilton County Courthouse shown on the following page, provided another pleasant location for Webster City's citizens to relax in the fresh air surrounded by well-attended lawns and gardens. Possibly some people took advantage of the park's benches while waiting for business to be conducted in the courthouse.

HAMILTON COUNTY COURTHOUSE, WEBSTER CITY. This three-story, brick building was dedicated on July 4, 1876, replacing an earlier courthouse that dated to the 1860s. The photograph at left shows the courthouse originally topped with an attractive 18-foot cupola, which, together with the symmetrical facade, added greatly to the building's presence and projected authority expected in the county's government center. The cupola had been removed when the picture below was taken in the late 1930s, and entry foyers had been added on two sides of the building. Although these additions may have been utilitarian, the building's original architecture was compromised, which detracted from the beauty of the historic structure.

Kendall Young Library, Webster City, Iowa

KENDALL YOUNG LIBRARY, 1201 WILLSON AVENUE, WEBSTER CITY. Kendall Young was an early and highly successful businessman in Webster City. Before settling there, he had been a farmer, soldier, commercial fisherman, and gold prospector. In 1859, he arrived in Webster City, where he opened a general store and later the city's first bank, in association with another early citizen L.L. Estes. When Young died in 1896, he willed his estate of $150,000 to the city for the establishment and maintenance of a free public library. The Beaux-Arts building was completed in 1905 at a cost of $50,000. Special features included gold marble columns from Africa, terrazzo and mosaic floors, stained-glass windows, and a stained-glass dome. The building underwent a seamless expansion in 1998 that enabled the exterior and interior of the original building to remain unchanged.

Post Office, Webster City, Iowa.

POST OFFICE, 801 WILLSON AVENUE, WEBSTER CITY. Walter Willson, another early citizen, is credited with naming the town Webster City, constructing several commercial buildings, and bringing the railroad and post office to the town in the 1850s. The building shown on this postcard dates to 1909. The attractive entrance faces both Willson Avenue and First Street. The building is in the National Register of Historic Places.

HOTEL WILLSON, SECOND AND DES MOINES STREETS, WEBSTER CITY. Walter Willson's entrepreneurial spirit included building this three-story hotel in the 1880s. Originally, it featured a large porch and a turret on the roof. Both of these features had been removed when this photograph was taken in the 1930s. The Hotel Willson maintained its presence in the center of Webster City's business district into the 1950s.

SECOND STREET BUSINESS DISTRICT, WEBSTER CITY. In most cities, historic Highway 20 coursed through the business district on either Main Street or First Street. Webster City was an exception as Second Street was the favored artery. Webster City was a thriving community at the times the photographs on this page were taken. The photograph above, from the 1930s, shows many cars on the street and a stop sign post in the center of the intersection. A Highway 20 shield is attached to the lamppost on the right of the picture. In the card below, the Rexall Drugstore, a fixture in Midwestern communities during that era, was prominently located on the street, and a small portion of the Hotel Willson can be identified in the right corner.

ELM STREET, WEBSTER CITY. During the early decades of the 20th century, city officials frequently chose a pleasant residential street to represent their community to the public. Elm Street paralleled Highway 20 a few blocks to the south and presented a picture of comfort and security. Substantial homes with large front porches and attractive lawns predominated the street. Streetlights had not been installed when this picture was taken.

FLAMINGO MOTEL, US HIGHWAY 20 AND 60, WEBSTER CITY. The owners of this establishment, located at the western city limits of Webster City, chose a decidedly warm-weather name for a motel located in the snowbelt. Outdoor seating and a large beach umbrella were provided to enhance the tropical ambiance they were trying to create.

PROMOTIONAL CARD, FORT DODGE. Both the beauty of the countryside and the rise in popularity of the "Auto" were communicated in this mid-1920s postcard promoting Fort Dodge. The sender attested to the veracity of the sentiment expressed on the face of the card. She wrote that they had "a beautiful drive through the park and across the river."

CROUSE'S MOTOR COURT, EAST ON HIGHWAY 20, FORT DODGE. This tourist court, located in the heart of the gypsum industry, featured cute cabins, well-manicured lawns, and a children's playground. A gas station and repair services were available for motorists. Panel Ray heaters became popular in the 1940s due to their compact size and efficiency. They were used primarily to heat house trailers, but they also worked well in small cabins.

Air View of the United States Gypsum Co. Mill, Fort Dodge, Iowa

US GYPSUM MILL AND PLYMOUTH GYPSUM MILL, FORT DODGE. Gypsum was discovered along the Des Moines River by geologist David Owen in 1852. Subsequently, the mineral beds were determined to be extensive and among the most pure gypsum deposits anywhere on earth. The mineral has been mined near Fort Dodge since 1872, making Webster County Iowa's leading gypsum-producing region and resulting in Fort Dodge acquiring the nickname "Gypsum City." Fort Dodge gypsum was used to produce the plaster of Paris covering the buildings and sculptures along the "Great White Way" at Chicago's 1893 world's fair. Over the years, more than 30 companies, including the two shown on this page, have been involved in mining and converting the raw stone into commercial products, primarily for the building industry.

BLANDEN MEMORIAL, FORT DODGE, IOWA

BLANDEN MEMORIAL ART MUSEUM, 920 THIRD AVENUE SOUTH, FORT DODGE. The Blanden Art Museum is located two blocks north of historic Highway 20 and has been a destination for art lovers for more than 80 years. The museum was the result of the efforts of a group of public-minded citizens who were determined that Fort Dodge should have a first-class art museum. Locally raised funds were supplemented by a gift from Elizabeth and Charles Blanden, the former mayor of Fort Dodge. Subsequently, Blanden decided to underwrite the entire cost of the building in honor of his wife. The building was deeded to the City of Fort Dodge at the dedication ceremony in 1932. It was the first public museum in Iowa. The Blanden Memorial Art Museum maintains an outstanding permanent collection of American, European, and Asian paintings, and it fulfills the founders' commitment to visual arts education.

MAIN STREET, LOOKING EAST AND WEST, FORT DODGE. Throughout the early decades of the 20th century, Fort Dodge's Central Avenue was a shining example of community progress. Eight buildings stood five or more stories high, the definition of skyscraper at the time, lending credence to the claim that Fort Dodge had more skyscrapers per capita than any city in the country. Twenty-four individual buildings are eligible for listing in the National Register of Historic Places. The Webster County Courthouse clock tower is clearly visible, as are several of the city's prominent businesses in both pictures. Professional offices typically occupied the floors above the storefront businesses. The multi-globe streetlamps in the mid-1930s photograph above had been replaced when the photograph below was taken only a few years later.

Webster County Court House, Fort Dodge, Iowa.

WEBSTER COUNTY COURTHOUSE, 701 CENTRAL AVENUE, FORT DODGE. Webster County was organized in 1852 and named for Daniel Webster, the famous US senator and statesman. The town of Homer was the first county seat, but within four years, it was moved to Fort Dodge. As both population and government business expanded, the county outgrew two earlier courthouses, necessitating the construction of the present building. The ornate Beaux-Arts–style courthouse, designed by architect Henry Kock, was completed in 1902 at a cost of almost $40,000. The courthouse has dominated the Fort Dodge business district ever since. The columned front facade exudes authority, and its clock tower is a landmark that has helped keep the citizens of Fort Dodge on time for over a century. The courthouse was listed in the National Register of Historic Places in 1981.

The Wahkonsa Hotel and Annex, Fort Dodge. Three of Fort Dodge's classic 1930s hotels are shown on this postcard. The dual-wing building on the left was the Warden Hotel and Apartments. Its first-floor arcade contained fashionable retail stores. The center building, identified here as the Wahkonsa Annex, was actually the Warden Annex. The low building at the extreme right is the Wahkonsa, considered the city's first really fine hotel.

Public Library, 601 First Avenue, Fort Dodge. In 1901, Fort Dodge received a $30,000 Carnegie Foundation grant to build a public library. The building, designed by Henry Kock, opened in October 1903. A second floor replaced the original domed roof in 1930, and the library served the community until a new library opened in 2000. The old building is in the National Register of Historic Places.

ARMORY, FIRST AVENUE AND SEVENTH STREET, FORT DODGE. The Armory was completed in 1904, spearheaded by the city's Commercial Club, which raised $8,000 to construct the building. The castle-like structure housed the National Guard Regiment and provided a venue for the community band and various civic events. From the 1930s through the 1950s, it was one of Iowa's premier ballrooms, hosting most of the famous big bands of the day.

TUG-OF-WAR, FORT DODGE. County fairs and various other community celebrations were popular forms of entertainment during the first half of the 20th century. Many involved teams composed of local citizens, and their games ranged from baseball to more humorous events, as displayed on this card. A tug-of-war with the losing team being pulled through a pool of mud was always worth the price of admission.

YMCA, 1422 First Avenue South, Fort Dodge. The building shown on this card dates to 1910 when it was constructed to house the Fort Dodge Young Men's Christian Association. Like YMCAs everywhere, it was dedicated to providing housing and promoting healthy lifestyles for young adults. In 1962, the building was replaced by the Fort Dodge Community Rec Center.

YWCA, 826 First Avenue North, Fort Dodge. The YWCA has served Fort Dodge in this building since 1914. Originally, the building housed young women who came to the city for education or employment. It included a cafeteria for residents and also was a social center available to the traveling public. The focus now has changed to a women's and family shelter for victims of abuse, which includes counseling and educational services.

Municipal Band Shell, Oleson Park, Fort Dodge, Iowa

MUNICIPAL BAND SHELL, OLESON PARK, FORT DODGE. Fort Dodge community bandmaster Karl King, the highly revered composer of marches and circus music, championed this award-winning band shell. Construction was authorized by the Works Progress Administration (WPA) after the Great Depression. The dedication was held in June 1938 with more than 15,000 people in attendance. It was rededicated and named for Karl King in July 1988.

Scene along Des Moines River, Loomis Park, Fort Dodge, Iowa

DES MOINES RIVER, LOOMIS PARK, FORT DODGE. The lovely Loomis Park is located along the Des Moines River on the west side of Fort Dodge. The park offered picnic areas, playgrounds for children, and hiking trails along the riverbank. Fishing from the shore or from the observation deck was a popular activity. The dam provided power for the hydroelectric plant on the opposite side of the river.

TONY'S FAMOUS RESTAURANT, SOUTH ON HIGHWAYS 20 AND 169, FORT DODGE. Tony's was a Fort Dodge establishment that was a favorite of the local population and travelers on historic Highway 20. Its themed dining rooms were especially popular. The walls of the Lariat Room were covered with a mural depicting a Western scene, and the mural in the Oriental Room featured Chinese figures.

TOWERS MOTEL, JUNCTION OF HIGHWAYS 20 AND 60, FORT DODGE. This 1950s-style motel provided all the amenities of the day, including a small black-and-white television set, the placement of which may have been more to accommodate this photograph rather than for the guests' viewing comfort. The motel contained 60 luxurious units furnished in fascinating motifs: French, East Asian, Italian, and Danish Modern.

DODGER MOTEL, SOUTH END OF BRIDGE ON US HIGHWAYS 20 AND 169, FORT DODGE. A selling point for this AAA-approved motel was "Sleep off the Highway." The small establishment consisted of 12 deluxe, air-conditioned units, each featuring airfoam mattresses. The design and telephone exchange number on the card suggest a 1940s date, but one guest had parked his 1920s automobile in the lower parking lot.

RURAL SCENE, BETWEEN FORT DODGE AND ROCKWELL CITY. Historic Highway 20 crossed fertile farmland between Fort Dodge and Rockwell City, which contributed to the region being termed the Corn Belt. Farm fields were interspersed with rolling hills offering the beautiful views shown on this card. The fields and farmsteads presented a picture of rural peace and tranquility for which Iowa was famous.

MAIN STREET, ROCKWELL CITY. Rockwell City's main street was buzzing with activity when this picture was taken in the mid-1930s. Two drugstores, a shoe store, a hardware store, and a restaurant can be identified in the closest block. A Western Auto hardware and auto parts store was located farther down the street.

CALHOUN COUNTY COURTHOUSE, ROCKWELL CITY. The attractive Calhoun County Courthouse has held center stage in Rockwell City since 1914. The building is sited on the city's public square where it is surrounded by a well-trimmed lawn. Careful maintenance has ensured that both the exterior and interior have remained essentially unchanged since the beginning, which has earned the building's listing in the National Register of Historic Places.

ADMINISTRATION BUILDING AND DORMITORY, WOMEN'S STATE REFORMATORY, ROCKWELL CITY. This reformatory, now called the North Central Correctional Facility, is located at the east edge of Rockwell City. The Iowa Official Register: 1939–1940 described it as follows: "Women over 18 years old, convicted of offenses which carry a term of more than 30 days, are sent to the Women's Reformatory at Rockwell City. The first prisoner was received on May 2, 1918. The population at the latest report was 66, with a normal capacity of 78. The women are given an opportunity to attend school and have various entertainments and amusements, including movies, dances, lectures and recitals, home talent plays and picnics."

CRAFT'S CABINS, ROCKWELL CITY. The writer of this card in 1930 reported that "everything is so good, we've had a good trip, but why not, No. 20 is a fine drive." The "X" apparently indicates the cabin this person occupied. The card was mailed from Orchard, Nebraska, a community on Highway 20 more than 200 miles west of Rockwell City, indicating that these travelers were on a westward journey.

GREETINGS FROM LYTTON. Lytton, located approximately 12 miles west of Rockwell City, is the westernmost town in Webster County through which historic Highway 20 passed. The population has remained at approximately 300 since the 1920s. Nevertheless, city officials sought attention for their community by providing postcard greetings to travelers. Pastoral scenes were popular subjects for these generic cards.

Four

Approaching the Missouri River

The most western section of Iowa's historic Highway 20 encompassed Sac, Ida, and Woodbury Counties. Sac City was the largest town in Sac and Ida Counties, and Early, Schaller, Galva, and Holstein were smaller communities. These counties were endowed with lush farmland that extended into eastern Woodbury County. Their agriculturally based economy supported the villages along the road, and the main street businesses provided for the needs of local residents and sources of supplies and refreshment for early travelers.

Correctionville in eastern Woodbury County is notable for having the longest single name of any city in Iowa. The name was derived from the correction lines used by surveyors to compensate for the fact that on a globe the north and south county borders cannot be equal. The correction line occurs at Fifth Street. It is not possible to drive on a north-south street without making a jog at Fifth Street. Correctionville was followed by Cushing and Moville, and shortly thereafter, the gradual transition from rural to suburban lifestyle began as the road approached Sioux City, Iowa's predominant northwestern city. Sioux City's metropolitan area encompasses three states, Iowa, Nebraska, and South Dakota. Historic Highway 20 was routed through Iowa and Nebraska, and parts of South Dakota could be viewed from Sioux City vantage points overlooking the Missouri River.

Modern Highway 20 now bypasses Sioux City on the east and south, but the original route still can be followed into the city. For the present-day traveler, County Road D22 on either side of Cushing, as well as Correctionville Road between Moville and Sioux City, provides an outstanding illustration of historic Highway 20 in Iowa. The latter route was paved in 1921 and is still a beautiful drive. The original road configuration through Sioux City's business district has changed slightly due to diversion of the Floyd River channel and urban renewal in the downtown, but it is still possible to approximate the course of the historic road before it crosses the Missouri River into Nebraska.

ENTRANCE TO TOURIST PARK, SAC CITY. Stone pillars topped by attractive lamps were the gateway to this park, located along the Raccoon River at the east edge of Sac City. Early travelers were afforded a pleasant setting in which to pitch their tents, and children had plenty of room to play. They could replenish their supplies or have a good meal in the business district, only a few blocks away.

CHAUTAUQUA AUDITORIUM, SAC CITY. Chautauqua was an adult education movement in the late 19th and early 20th centuries. This auditorium, built in 1908, is the last Chautauqua building remaining in Iowa. Civic and religious events and family gatherings were popular activities that were held at the auditorium, and famous orators, including William Jennings Bryan, have spoken from its stage. The auditorium has been carefully maintained and is still in use.

FIRST LOG CABIN IN SAC COUNTY, SAC CITY. Judge Eugene Criss arrived in what was to become Sac City in early 1855 determined to build a community on the Raccoon River. He built the log cabin shown on this card and also a log hotel, stagecoach stop, and general store. The latter buildings are gone, but the cabin remains in the park adjacent to the Chautauqua auditorium.

IRWIN MOTEL, EAST MAIN STREET, SAC CITY. This classic small-town motel has served the needs of visitors to Sac City for almost 50 years. Located directly on historic Highway 20, it was a convenient place where motorists could pull off the road to spend the night in one of the motel's comfortably furnished guest rooms.

EAST BRIDGE AND RACCOON RIVER, SAC CITY. Many Iowa cities chose to emphasize their beauty by producing postcards showing scenes along the river that flowed through their communities. The attractive two-arch Highway 20 bridge in the picture above provided those views in Sac City. The superstructure included decorative cast concrete designs on the railings and piers that added architectural interest to the bridge. In the picture below, the peaceful river reflected the trees and thick underbrush along the riverbanks and offered a perfect place for canoeing and fishing in the summer and ice-skating in the winter.

MONUMENT SQUARE, SAC CITY. Located directly across the street from both the historic Sac County Courthouse and Sac City Municipal Building, this was said to be the northernmost monument in the United States dedicated to the soldiers who fought for the Union army. The height of the monument is 19 feet. It consists of a bronze soldier at the top and the names of Sac County soldiers who served in the Civil War inscribed on the sides of the granite base (above). The monument was dedicated on November 21, 1894. When the pictures on this page were taken, four period cannons, one of which is shown in the photograph at right, surrounded the statue. Subsequently, these cannons were replaced by cannons from World War II.

SAC COUNTY COURTHOUSE, SAC CITY. Sac County was established in 1856 and named for the area's predominant Sac Indian tribe. The county seat was established "as near the geographic center as may be, having due regard for the present as well as future population." The building shown on this postcard was completed in 1890 and is still in use. It is listed in the National Register of Historic Places.

PARK HOTEL, WILLIAMS STREET AND FIFTH STREET, SAC CITY. Throughout the first half of the 20th century, the Park Hotel provided the best accommodations for visitors and the center for various activities of the town. The hotel was built in the late 1800s and was remodeled in 1912. It remained essentially unchanged for over 50 years. This card shows the hotel as it appeared in the late 1920s.

MAIN STREET, SAC CITY. The two cards on this page illustrate the evolution of Sac City's Main Street over a period of 15 to 20 years. The photograph above was taken in the mid-1930s, and the photograph below was taken in the late 1940s or early 1950s. The old-style streetlamps in the earlier picture had been replaced with higher and brighter models. Wallen's Variety Store and the Wigwam Bakery occupied prominent locations opposite each other in both pictures. Their facades and those of many other stores had been updated, but the general appearance of the street is much the same in both pictures. The teenage girls in the photograph below wearing pedal pushers, the style of the era, probably now are grandmothers.

PUBLIC LIBRARY, 615 MAIN STREET, SAC CITY. This library was endowed through an $8,000 Carnegie Foundation grant in 1913. It has been a Main Street fixture for 100 years, but the writer's thoughts were elsewhere when this card was written in the late 1920s. She wrote "Ed has a new Ford and has been entertaining us women right royally," including a drive to Storm Lake, 25 miles away.

CARLSON HOUSE, MAIN STREET, SAC CITY. An early citizen of Sac City, Judge John Carr Early, built this Victorian mansion in 1875 on a hill a short distance west of the town's business district. Over the years, the house had been a family home, hospital, and an apartment house. When this card was produced in the 1960s, it was a restaurant noted for "food at its finest."

BUSINESS DISTRICT, SECOND STREET, EARLY. Early, Iowa, was named for one of the area's first settlers, D.C. Early. Highway 20 was still a gravel road as it passed through the town in the 1920s. Automobiles were becoming more popular as several Model T Fords are parked at the curb, and one car is approaching down the street. Two gentlemen are relaxing on the doorstep of the building on the right.

MATT'S TOURIST COURT, US20 AT FIFTH STREET, EARLY. The writer of this card told her friend that they had spent the night at this tourist court. They were having a fine trip and had left that morning for New York. The card was mailed to a California address so it is possible that they were making a cross-country journey and probably were following Highway 20 most of the way.

SOUTH MAIN STREET, SCHALLER. This residential street in Schaller was typical of most small communities. Frame houses and broad lawns predominated, but the exception is the size of the trees, which are not characteristic of a long-established neighborhood. The trunks are all quite small, indicating that these trees may have been planted more recently. Possibly, the original trees were destroyed by a storm or disease.

M.E CHURCH, 300 CRAWFORD STREET, GALVA. The writer of this card did not give a reason for being in Galva, but she obviously was not a native Iowan. She asked her friend in Chicago, "Is this rural enough for you?" She went on to say that she could see grazing cows, waving cornfields, and "they even have sidewalks here but they don't show up on the card!"

STANDPIPE, HOLSTEIN, IOWA. Standpipe is an archaic name for water towers that overlook towns and villages throughout the nation. Often it was the highest structure in the town and could be seen from miles around. Many had the name of the town painted on the tank. A common children's game while traveling by automobile was to see who first spotted the water tower in the next town.

MAIN STREET HOMES, HOLSTEIN. Travelers following historic Highway 20 during the road's early decades quickly learned that wood-frame houses were a staple, especially in the Midwest where lumber was plentiful. The houses were modest in size, and their design demonstrated certain similarities, especially the front porch. There is no evidence that electric streetlights had extended into this residential neighborhood.

MAIN STREET BUSINESS DISTRICT, HOLSTEIN. The two pictures on this page were taken from virtually the same location. They reflect stability and progress on Holstein's Main Street over an approximately 20-year span. Many of the storefronts had undergone only slight changes, such as new signs on the café, tavern, and Coast-to-Coast store. According to the signs on the door, the Masonic lodge above the Coast-to-Coast store had been replaced by the American Legion hall, and a "Stop for Pedestrians" sign had been placed in the intersection. The most notable changes include the institution of parallel parking and installation of more powerful electric streetlamps. More than doubling the size of the grain elevator at the end of Main Street was confirmation of the positive effect of agriculture on the town's economy.

CITY PARK, HOLSTEIN. The park in Holstein was located a few blocks south of historic Highway 20, but it still would have been convenient for early motorists to take a break from their journey. In contrast to other towns that were built around a public square surrounded by businesses, civic buildings, and churches, this park was located amid the attractive homes of community residents.

SAVINGS BANK, CUSHING. Residents could rely on the Cushing Saving Bank to be the guardian of their money. The two-story, brick building had a dominant presence on Main Street and gave the impression of security. In many Main Street buildings, the second floor housed various professional offices. Here, the sign in the window indicates that the office above the bank was occupied by the justice of the peace.

City Reservoir, Correctionville, Iowa.

CITY RESERVOIR AND WINDMILL, CORRECTIONVILLE. The Correctionville water tower was of older-style construction than in neighboring Holstein. This tower consisted of a brick base, and windows at various levels indicated an internal staircase leading to the tank at the top. This tank appears to be made of wood stabilized by a series of circumferential cables. A typical farm windmill appears in the background of the picture.

MAIN STREET, CORRECTIONVILLE. This Chevrolet dealer was ready to service motorists in Correctionville. He handled Good Year tires, Mobil Oil products, and sold gasoline from curbside pumps. A hand-operated lever pumped gas into a large glass cylinder, which was marked with lines so the customer could see the amount of gas being purchased. It then flowed by gravity into the car's tank, taking several cycles to completely fill-up.

RESIDENCE STREET, MOVILLE. The street shown above appears to have been undergoing development at the time this card was produced, possibly in preparation for the coming of Highway 20. Sidewalks and telephone poles had been strategically placed along the street, and what appears to be the bases for streetlights were present. This card, too, shows very young trees in front of these stately homes in Moville.

SYNDICATE BLOCK, MOVILLE. Two gentlemen were having a chat on the corner, and a young child was riding his tricycle on the sidewalk in front of a store located on Moville's Main Street. The elevated sidewalk protected pedestrians from mud as the roadbed appears to still be gravel when this postcard was produced in the 1920s.

MOTEL 20, HIGHWAY 20, MOVILLE. No doubt guests at this motel, named to emphasize its location on historic Highway 20, expected the normal amenities of the day: foam mattresses, hot water heat, telephone, and good restaurants nearby. They probably were surprised to see a herd of buffalo strolling through the parking lot. Other wildlife attractions on the premises included deer and peacocks.

Bel-Aire Motel "*Best in the West*"

NEW—ALL NEW!!—Silent Central Heating and AIR CONDITIONED
Ceramic Tile Bath, Shower and Tub. Wall to Wall Carpeting!
Telephone! Television! Off the Hi-Way!

BEL-AIRE MOTEL—2921 East Gordon Drive, Hi-way 20. Sioux City, Iowa
Phone 2-3206

BEL-AIRE MOTEL, 2921 EAST GORDON DRIVE, HIGHWAY 20, SIOUX CITY. There is no postmark on this card, but the car parked behind this motel indicates that it was produced in approximately 1950. Although modest in size, the "NEW-ALL NEW!!" Bel-Aire appears to have offered everything the traveler of the day might desire, including air-conditioning, telephone, television, and wall-to-wall carpeting.

MORNINGSIDE AND BRIAR CLIFF COLLEGES, SIOUX CITY. Historic Highway 20 was the foremost east-west road that served students and visitors to both of these Sioux City colleges during the early history of the federal highway system. Both are private, coeducational, liberal arts institutions located in the eastern and northern sections of Sioux City respectively. Morningside is the older, having been founded in 1894 by the Methodist Episcopal Church. The building shown above is Lewis Hall, one of the oldest structures on the campus. Briar Cliff was founded in 1930 as a Catholic institution for women. Men were admitted for the first time in 1965, and the coeducation was formalized in 1967. Heelan Hall, shown below, was the college's original building.

GRAND AVENUE VIADUCT, SIOUX CITY. Constructed in 1937 and now called the Gordon Avenue Viaduct, this mile-long elevated highway provided a new eastern portal of entry into Sioux City. It carried historic Highway 20 traffic from the eastern suburbs to the downtown business district, eliminating the need to follow surface streets through the enormous stockyards and over the dangerous grade crossings of more than 20 railroads that served the city.

MUNICIPAL AUDITORIUM, 401 GORDON DRIVE, SIOUX CITY. This 7,000-seat auditorium was designed in 1938 to replace the outdated Memorial Auditorium in downtown Sioux City. Ground was broken in 1941, but delays caused by World War II shortages brought the effort to a halt. Construction resumed in 1947, and the ornate building finally was completed in 1950. The building has been a venue of conventions, graduations, concerts, and sporting events.

FOURTH ST. LOOKING WEST, SIOUX CITY, IOWA 1330

FOURTH STREET, LOOKING WEST AND EAST, SIOUX CITY. Historic Highway 20 followed Fourth Street directly through Sioux City's business district before crossing the Missouri River into Nebraska. The late-1920s postcard above and the mid-1930s postcard below show the appearance of the street during the early years of the road. The white building in both photographs is the Badgerow Building. Identifiable businesses in the photograph above include Voss Lunch and E&W Clothing. The Loop Theater was featuring the 1931 movie *Wild Horse*, starring Hoot Gibson, and one store was having a "Quitting business" sale. In the photograph below, the Kresge store, Martin Hotel, Security Bank, and Katz drugstore are evident as well as a billboard advertising Old Home Bread. What looks like spots in the photograph above are actually birds flying over the street.

FOURTH STREET LOOKING EAST, SIOUX CITY, IOWA

MILNER HOTEL, 807 FOURTH STREET, SIOUX CITY. The 150-room Chicago House Hotel opened in 1905 and immediately took its place among the area's finest hotels. The unique three-bay design provided direct sunlight to guest rooms throughout the building. The hotel continued under the name Chicago House until 1936, when it joined a coast-to-coast chain and was renamed the Milner. Daily room rates ranged from $1 to $1.50.

HOTEL WEST, SIOUX CITY. The Hotel West was another of Sioux City's finer hotels during the early decades of the 20th century. Located on Nebraska Street, less than one block from its junction with Fourth Street, the hotel's attractive lounge was a popular place to gather for a drink or dinner. The hotel offered air-conditioned guest rooms at a cost of $1.25 to $2.50.

TOLLER'S DRUGSTORE, SIXTH AND PIERCE STREETS, SIOUX CITY. The description on the back of this card proclaims Toller's to be the finest drugstore in America, with the largest prescription laboratory in the Midwest. The 9,000-square-foot drugstore featured Rexall products. Moreover, the store housed the famous Star Light Room, which served the finest food. Toller's occupied this location beginning in 1911. The drugstore has closed, but the building still exists.

NEW FRANCES-ORPHEUM THEATER BUILDING, 520–528 PIERCE STREET, SIOUX CITY. This multistory theater was built in 1927. It featured 2,650 seats in the elaborate auditorium and over the years was host to vaudeville, legitimate theater, dance, musical productions, and motion pictures. Broadway stars, including Fred Astaire and Katherine Hepburn, appeared on stage. The theater is in the National Register of Historic Places.

BADGEROW BUILDING, FOURTH AND JACKSON STREETS, SIOUX CITY. This large office building has been a dominant presence on Fourth Street since 1930. It was named for Gordon Badgerow, a prominent citizen in early Sioux City. The building was placed in the National Register of Historic Places in 1983, and it was named one of Iowa's 100 top buildings of the 20th century by the Association of Architects in 2004.

YOUNKER-DAVIDSONS DEPARTMENT STORE, 407 FOURTH STREET, SIOUX CITY. Brothers Ben, Dave, and Abe Davidson started this landmark business in the late 1800s. Throughout the first half of the 20th century, their small storefront store grew into the largest department store in Iowa. Younker Stores purchased Davidsons in 1948, and Younker-Davidsons remained an anchor store in Sioux City's center city until closing in 2007.

MARTIN HOTEL, FOURTH AND PIERCE STREETS, SIOUX CITY. The 350-room Martin Hotel (above) was completed in 1913 and enlarged in 1918. During the first half of the 20th century, it reigned as Sioux City's finest hotel. The hotel continued in operation until 1963, when it was converted to senior citizen apartments. During renovation of the building in 1979, a long-forgotten mural by artist Grant Wood was discovered under wallpaper in the hotel's Corn Room. The 6.5-by-50-foot mural, painted in 1927, covered all four walls of the room. The mural was removed and donated to the Sioux City Art Center where it is now a part of that institution's permanent collection. The hotel's spacious dining room is featured in the photograph below.

PUBLIC LIBRARY, 705 SIXTH STREET, SIOUX CITY. A grant from Andrew Carnegie enabled the construction of Sioux City's Free Public Library in 1912. The architectural design stressed open spaces and natural light in the reading rooms. The library served the public until 1985 but was in danger of being demolished after it closed. Fortunately, forward-thinking agencies secured funds to convert the building into 20 apartments for low-income renters.

WARRIOR HOTEL, 525 SIXTH STREET, SIOUX CITY. The 10-story, 300-room Warrior Hotel was a convenient stopping point for visitors in Sioux City. Completed in 1930, it was one of Sioux City's finest examples of Art Deco design. The hotel served local citizens and the traveling public for 40 years before closing in 1970.

WHITE HORSE PATROL, SIOUX CITY. The Abu Bekr Shrine White Horse Patrol has been a premier Sioux City attraction since 1920. It has performed at notable events from coast to coast, including a Presidential Inaugural Parade, the Rose and Cotton Bowl Parades, the East-West Shrine football game, and at functions in many other cities. Initially, personal horses of assorted sizes and colors were ridden, but over the years, a keen eye for quality and sound breeding selection enabled the troupe to evolve into perfectly matched white horses that must meet strict criteria to be included. The horses are still stabled and cared for by their individual owners, who come together for training and performances. The White Horse Patrol contributes to Abu Bekr Temple's support for the Shriners' Children's Hospital and Burn Institutes.

FLOYD MONUMENT, FLOYD PARK, SIOUX CITY. Sgt. Charles Floyd, the only person who died on the Lewis and Clark expedition, is buried in Sioux City. The 1804 diagnosis was bilious colic, a condition now thought to have been a ruptured appendix. A stone obelisk marks his grave. It is the nation's first nationally registered historical landmark.

GRAVE OF CHIEF WAR EAGLE, SIOUX CITY. Throughout his life, War Eagle worked for peace between the native tribes and also with the white settlers. He was awarded a Silver Medal from Pres. Martin Van Buren in recognition of his service to the government during the War of 1812. War Eagle died in 1851 and was buried on a cliff overlooking the confluence of the Big Sioux and Missouri Rivers.

THREE STATE VIEW FROM WAR EAGLE GRAVE, SIOUX CITY. The high cliff on the Iowa side of the Missouri River awarded visitors with a spectacular view of the river valley and the land extending from Iowa into Nebraska and South Dakota. The "Big Muddy," as the Missouri sometimes was called, appears placid, and lush farmland extends for miles in every direction.

COMBINATION BRIDGE, SIOUX CITY. This four-span bridge linked Sioux City, Iowa, and South Sioux City, Nebraska, over the Missouri River. Construction was completed in 1896, and it bore Highway 20 traffic until 1981. Its name, Combination Bridge, resulted from its serving pedestrian, wagon, automobile, and light rail traffic. The bridge was an engineering marvel. The section in the foreground of the picture rotated 90 degrees to allow river traffic to pass.

127

Discover Thousands of Local History Books Featuring Millions of Vintage Images

Arcadia Publishing, the leading local history publisher in the United States, is committed to making history accessible and meaningful through publishing books that celebrate and preserve the heritage of America's people and places.

Find more books like this at
www.arcadiapublishing.com

Search for your hometown history, your old stomping grounds, and even your favorite sports team.

Consistent with our mission to preserve history on a local level, this book was printed in South Carolina on American-made paper and manufactured entirely in the United States. Products carrying the accredited Forest Stewardship Council (FSC) label are printed on 100 percent FSC-certified paper.

MADE IN THE USA